ESSENTIAL **10**

VIDEO

ESSENTIAL TIPS

VIDEO

Roland Lewis

DORLING KINDERSLEY

London • New York • Stuttgart • Moscow

A DORLING KINDERSLEY BOOK

Editor Damien Moore
Art Editor Clive Hayball
DTP Designer Mark Bracey
Series Editor Charlotte Davies
Managing Art Editor Amanda Lunn
Production Controller Louise Daly
US Editor Laaren Brown

First American Edition, 1995
2 4 6 8 10 9 7 5 3 1
Published in the United States by
Dorling Kindersley Publishing, Inc.,
95 Madison Avenue,
New York, New York 10016

Distributed by Houghton Mifflin Company, Boston.

ISBN 0-7894-0183-5

Text film output by The Right Type, Great Britain
Reproduced in Singapore by Colourscan
Printed and bound in Italy by Graphicom

ESSENTIAL TIPS

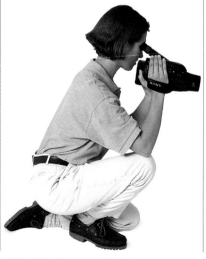

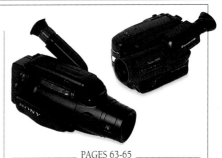

CHOOSING EQUIPMENT

1 WHAT IS A CAMCORDER?

A camcorder is a camera and a video recorder combined into a single compact unit that is able to record moving color images with sound. Camcorders are remarkably easy to use, and they give the immediate satisfaction of being able to check a scene as soon as it has been shot. If you are not entirely happy with the result, you can simply record over your original effort until you get it right.

■ Basic camera functions are usually fully automated, although more advanced models will offer manual overrides.

■ The more elaborate camcorders often offer digital processing options for producing specialized visual effects.

The viewfinder also functions as a monitor

A rocker switch controls the zoom

POWER SOURCES
Your camcorder runs on rechargeable batteries. It can also be powered from an outlet or from a car battery. Always use batteries of the voltage specified for your model, and never use them with other equipment. Store batteries in a cool place and be sure to discharge them fully before recharging.

The rechargeable battery is attached to the back of the camcorder

The start/stop button is used to start recording

An adjustable grip-strap is attached to the right side to help secure the camcorder

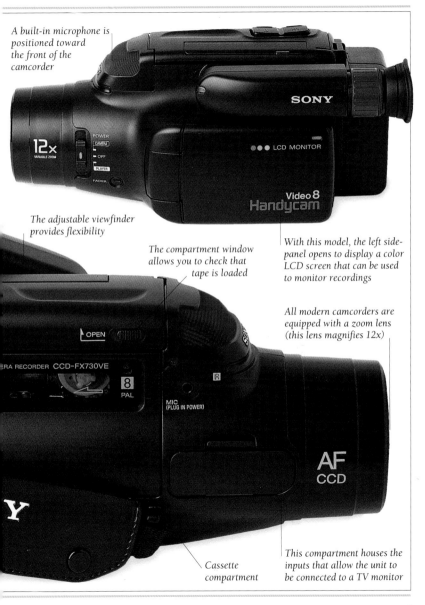

A built-in microphone is positioned toward the front of the camcorder

The adjustable viewfinder provides flexibility

The compartment window allows you to check that tape is loaded

With this model, the left side-panel opens to display a color LCD screen that can be used to monitor recordings

All modern camcorders are equipped with a zoom lens (this lens magnifies 12x)

Cassette compartment

This compartment houses the inputs that allow the unit to be connected to a TV monitor

2 WHICH CAMCORDER IS FOR YOU?

Familiarize yourself with the range of capabilities offered by various camcorders so that you can choose a model that suits your needs. The simplest machines are fully automated for "point and shoot" recordings; others bristle with controls that allow greater personal creativity.

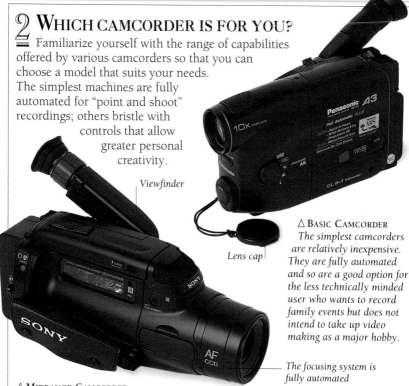

Viewfinder

Lens cap

△ **BASIC CAMCORDER**
The simplest camcorders are relatively inexpensive. They are fully automated and so are a good option for the less technically minded user who wants to record family events but does not intend to take up video making as a major hobby.

The focusing system is fully automated

△ **MIDRANGE CAMCORDER**
Consider buying a midrange model if you intend to take video making a little more seriously. The extra capabilities provided by midrange models can add a more professional touch to your video recordings.

ENTHUSIAST'S CAMCORDER ▷
For the real enthusiast, models are available with a wide range of special functions that can be used to enhance your recordings. However, the price of these machines is often as daunting as the complexity of their controls.

Special effects control buttons

3 CAMCORDER FORMATS

When buying a camcorder, consider which format (tape size) best suits your needs. The VHS format is convenient – it is compatible with most domestic VCRs. Video 8 is a smaller format (8mm tape cassettes are only slightly bigger than audio cassettes).

S-VHS tape

Hi8 tape

COMPACT OPTION ▷
VHS-C is an excellent compromise. Use an adaptor to play back these half-inch tapes on a VHS-type VCR.

Adaptor

S-VHS-C tape

△ **HIGH BAND OPTION**
S-VHS, S-VHS-C, and Hi8 are high band versions of the three different formats. These produce improved image quality, but tapes can only be played back on high band VCRs.

TELECONVERTERS

4 CHOOSING CONVERTER LENSES

Increase the telephoto or wide-angle range of your zoom lens with converter lenses. By using a wide-angle converter you can compensate for the limited angle of view provided by zoom lenses. It becomes increasingly difficult to maintain a steady image as the focal length of your lens increases, so before you invest in a long teleconverter lens you should consider purchasing a good-quality tripod.

WHICH CONVERTER?
Teleconverters are especially useful for recording images of wildlife and other subjects that are difficult to approach. Wide-angle converters are useful for shooting landscapes and interiors. Before buying a converter, check its effect on your autofocus and motor.

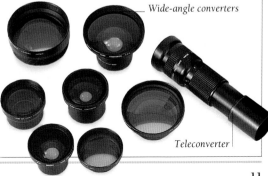

Wide-angle converters

Teleconverter

5 FILTER EFFECTS

Use filters to produce special visual effects or to compensate for problematic lighting conditions. An ultraviolet (UV) filter is the most valuable filter for video. It reduces the blue haze that commonly appears on outdoor sequences shot in sunny weather. It can be left permanently attached to protect the lens element.

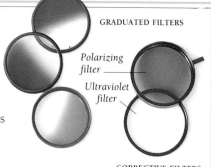

GRADUATED FILTERS

Polarizing filter

Ultraviolet filter

CORRECTIVE FILTERS

6 CAMCORDER LIGHTS

Although most camcorders are designed to produce pictures under very low light levels (images can be recorded by candlelight), the best-quality images are produced with bright lighting. Choose from a wide variety of video lights, ranging from small, inexpensive battery-operated units to more powerful electrically powered lighting.

Coiled cable attaches to battery pack

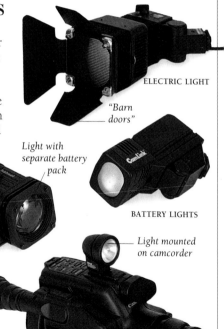

ELECTRIC LIGHT

"Barn doors"

Light with separate battery pack

BATTERY LIGHTS

Light mounted on camcorder

Sungun

LIGHTING EQUIPMENT
Much lighting equipment is designed for mobile operation. Some small lights can be mounted onto a camcorder's hotshoe.

7 TRIPODS & SUPPORTS

A tripod or an alternative form of support is often essential for producing steady images with your camcorder.

- Portability is, of course, an important consideration, but do not be tempted to sacrifice strength for lightness. It is counterproductive to employ a flimsy tripod that will tremble, or perhaps topple over, in the first gust of wind.
- A shoulder brace or a chest pod can help provide stability when you are recording on the move.

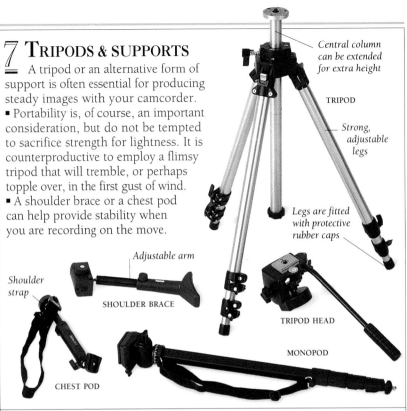

Central column can be extended for extra height

TRIPOD

Strong, adjustable legs

Legs are fitted with protective rubber caps

Adjustable arm

Shoulder strap

SHOULDER BRACE

TRIPOD HEAD

MONOPOD

CHEST POD

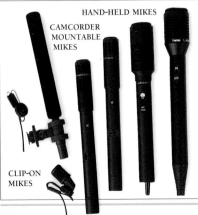

HAND-HELD MIKES

CAMCORDER MOUNTABLE MIKES

CLIP-ON MIKES

8 MICROPHONES

Extend the range and improve the quality of your sound recordings by including a supplementary mike in your collection of accessories.

- Some microphones can be mounted directly onto the camera to override the machine's built-in microphone.
- The quality of the recording and the potential uses of the various types of mikes depends upon their angle of acceptance of sound (*see p.51*).

13

9 HEADPHONES

Monitor the sound coming into the recording system by using headphones. Personal earphones will suffice, but the larger, closed-back headphones that cover up the ears are more effective for eliminating unwanted and distracting background noises.

▪ If necessary, be prepared to move your shooting position to avoid unwanted background noise.

▪ The level of sound is regulated automatically by your camcorder.

Commentary microphone

CLOSED-BACK HEADPHONES

10 CARE & CLEANING

Camcorders are precision instruments that must be regularly maintained and handled with care at all times. Avoid contact with dust, sand, and water, all of which can cause irreparable damage. Always replace the lens cap and remove the battery and tape when not in use.

Clean the camera body with an antistatic cloth

Use a blower brush to clean the lens

Anticondensation agent should be used in your camera bag

Lens cloth

Lens-cleaning fluid and tissues

A UV filter will protect the lens during shooting

11 CAMCORDER BAGS

A sturdy, weatherproof bag is essential for transporting your equipment safely.

- Choose a bag that is big enough to accommodate a range of accessories.
- A soft bag with accessory pockets will accommodate any design of compact camcorder and allow easy access to your equipment.
- Rigid cases offer greater protection, and you may even be able to use the case as a convenient platform to gain extra height while shooting.

COMPACT SHOULDER BAG ▽ △
Lightweight canvas bags are ideal for protecting smaller camcorders. A shoulder bag should have a strong strap, and enough room to store spare batteries and tapes.

Pouch for spare tapes and batteries

Cut the shape of your camera and accessories into the foam

◁ ALUMINUM CASE
Aluminum cases provide the most effective protection for your equipment, but they are a relatively expensive option.

BASIC TECHNIQUES

12 UNDERSTANDING APERTURE

The term "aperture" refers to the lens opening, which determines the amount of light that reaches your camcorder's sensors. The aperture size is controlled electronically as a principal component in the camera's automatic exposure system. The auto-exposure system is a great benefit: it allows you to concentrate fully on other aspects of shooting. However, there are some situations where the lighting conditions will be misread and manual overrides are useful.

The camera's iris is composed of overlapping metal leaves

The iris's aperture controls the amount of light reaching the sensor

IRIS DIAPHRAGM △
The iris diaphragm, composed of overlapping metallic leaves, is under direct electronic control. It adjusts the aperture as you shoot, and the results are visible in the viewfinder.

BRIGHT CONDITIONS
In bright sunlight, the iris closes down to create a small aperture.

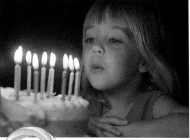

CANDLELIGHT EXPOSURE
In low light the iris opens up so that the aperture reaches its greatest width.

13 THE RIGHT EXPOSURE FOR THE SUBJECT

Your camcorder auto-exposure is designed to give the best results in bright conditions. The pictures produced are sharp and the colors appear natural. However, images can still be obtained in low light levels, and, although the pictures will not have the clarity obtained in bright conditions, there will be times when the soft, grainy low-light image will be more in keeping with the mood of the subject (*see below left*). Also, overexposure (*see below right*) can enhance certain images.

UNDEREXPOSED SHOT

"CORRECT" EXPOSURE

OVEREXPOSED SHOT

14 PROBLEMS WITH AUTO-EXPOSURE

Certain situations can cause problems for auto-exposure systems:
- There will be a noticeable change in exposure if a shot moves from an area of bright light into deep shade. Expose manually, or treat the two areas as different shots and reshoot.
- Another common problem occurs if a landscape is set against too great an expanse of sky. The sensors will read light from the sky and the landscape will appear too dark (*see below*).

△ UNDEREXPOSED LANDSCAPE
Here, the camcorder's sensors have read exposure for the expanse of sky.

△ CORRECT EXPOSURE
Tilting the camera downward to include more foreground corrects the exposure.

15 HOW TO COPE WITH BACKLIGHTING

Backlighting frequently causes problems for auto-exposure systems. When, for example, you are shooting indoors and your subject is standing against a bright window, the aperture will close down and the subject may appear in silhouette. Many cameras have a backlight compensator, which can be used to rectify the exposure in such circumstances. A "gain" facility will produce a similar effect, but will cause image quality deterioration.

SUBJECT APPEARS IN SILHOUETTE
A subject standing against backlighting may appear dramatically underexposed.

IMAGE USING BACKLIGHT COMPENSATOR
Backlight compensation widens the aperture so that the subject appears correctly exposed.

16 FOCUSING YOUR CAMCORDER

All modern camcorders have some form of autofocus system that gives the user the freedom to concentrate on composing shots. Today's autofocus systems are so advanced that they are able to keep a shot in focus even when the camcorder or the subject is on the move. However, there are situations that will mislead the autofocus system, so having a manual focus override facility is a real advantage.

FOCUS OPTIONS
Many camcorders offer a choice of auto- or manual focusing. Here, the controls are under the lens.

17 USING MANUAL FOCUS FOR CREATIVITY

Manual focusing demands a degree of skill, so get into the habit of practicing each shot before actually taking it. View your subject through the viewfinder and rotate the focus ring (usually situated on the lens barrel) until the image becomes sharp. Be particularly careful when following a moving subject. Learn which direction you need to rotate the ring to maintain sharp focus on a moving subject.

- Use manual focusing to direct your viewer's attention by shifting the focus between different subjects.
- An effective focusing technique is to open a shot with the subject out of focus and pull it into sharp relief.

△ UNFOCUSED IMAGE
A useful creative technique is to open with a shot that is deliberately out of focus.

PULL FOCUS ▷
The subject has been pulled into focus, bringing the lily bloom into sharp relief.

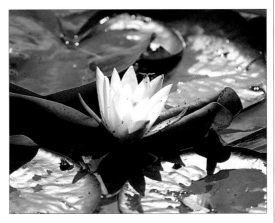

CLOSE FOCUSING ON A FLOWER

18 CLOSE FOCUSING

Be aware of your camcorder's minimum focusing distance, which is usually about 3 feet (1 m). Any object within this distance will be out of focus. Switch to your macro facility (if available), or fit a macro converter for extreme close-up shots. Always use a tripod when using a macro setting, and be aware of the shallow depth of field (*see p.21*).

19 PROBLEMS WITH AUTOFOCUSING

Despite the sophistication of modern autofocusing systems, there are certain shots that are problematic:

▪ Many focusing systems are centrally biased and subjects that are framed off-center will be thrown out of focus.

▪ Fast-moving subjects are difficult for autofocus systems. The subject often fluctuates in and out of focus as the system tries to keep pace.

▪ Rain, snow, and water surfaces can also "confuse" an autofocus system.

▪ Subjects behind bars or netting are difficult, as are rows of trees or posts.

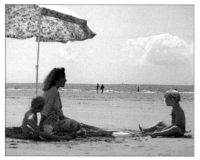

△ SUBJECT OFF-CENTER
When the main subject is positioned at the edge of the frame, use manual focus to lock onto your subject and reframe the shot.

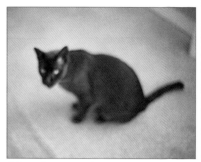

△ POOR LIGHTING CONDITIONS
Autofocus systems are less effective in dim light. Here, the nonreflective coat of the cat creates difficulty for an infrared system.

△ SUBJECT BEHIND NETTING
Use manual focus to avoid the camcorder focusing on the netting in the foreground.

FAST-MOVING SUBJECT ▷
Use a wide-angle lens setting to help focus on fast-moving subjects, such as this skier.

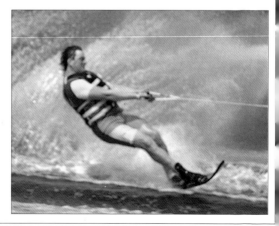

20 UNDERSTANDING DEPTH OF FIELD

The term "depth of field" refers to the distance between the nearest and the farthest points in focus. Focal length, subject distance, and aperture size (normally dictated by light intensity) all influence the depth of field.

△ SMALL APERTURE SETTING
A small aperture setting creates a deeper depth of field. Here, both of the subjects in the frame are in acceptably sharp focus.

△ WIDE APERTURE SETTING
A wide aperture setting creates a relatively shallow depth of field. Here, the subject in the background is thrown out of focus.

21 COLOR BALANCE

Remember that although our eyes naturally compensate for the differences between artificial light and daylight, your camcorder must be set to ensure that the rendering of color is accurate. Most camcorders use automatic white balance (AWB), but others must be set manually to avoid creating unnatural color casts.

In daylight, the tungsten setting results in a blue cast

The daylight setting records the colors correctly

SHOOTING IN DAYLIGHT △
The daylight setting is used to produce the correct color reproduction outdoors.

The daylight setting results in an orange cast indoors

The tungsten setting records indoor colors correctly

SHOOTING IN ARTIFICIAL LIGHT △
The tungsten setting is used to produce the correct color reproduction for indoor shots.

22 MAKING THE MOST OF FILTERS

Take time to experiment with filters that can enhance your images.
- Avoid using too many special filter effects when shooting your video: the results will appear contrived.

- Use a neutral density filter to reduce the depth of field in bright weather.
- Polarizing filters are very practical; rotate the filter to improve the image sharpness and color saturation.

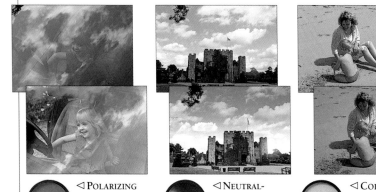

◁ POLARIZING FILTERS
Use a polarizing filter to reduce the reflections in glass and other nonmetallic surfaces.

◁ NEUTRAL-DENSITY FILTERS
A graduated neutral-density filter can be used to balance the exposure of the skyline.

◁ COLORED FILTERS
Here, a pink filter was used to add warmth to the scene and to improve flesh tones.

23 COPING WITH CONTRAST

Take care when shooting in strong, direct sunlight: detail in the deep shadows, though visible to the human eye, will be lost on video. Take separate shots of the area in shadow, or simply wait for the sun to disappear behind a cloud. Hazy days give more even light.
- A neutral-density filter can be used to reduce contrast ratios.

The figures under the umbrella are underexposed in the deep shadow

A cloud passes across the sun, giving a more even light with softer shadowed areas

SHOOTING IN BRIGHT SUNLIGHT
Sunlight adds sparkle and produces rich, vivid colors. But duller light is often more effective.

MANIPULATING YOUR CAMCORDER

24 HOLDING YOUR CAMCORDER

Always support your camcorder (even the lightest models) with both hands. The right hand is secured by a grip strap and is used to operate the main controls; the left hand is free to help stabilize the camcorder and to operate any other control switches.

- To avoid camera shake, use a wide angle as much as possible when taking handheld shots.
- Never carry your camcorder by the lens, microphone, or viewfinder housing.

Support the camera base with your left hand

FRONT VIEW OF GRIP

Rocker switch position

The start/stop trigger is positioned so that it can be operated by the thumb

GETTING A GRIP
Hold your camcorder firmly with the grip strap tightened over your right hand. The start/stop trigger is operated by the thumb, and the zoom rocker switch is controlled by the first and second fingers.

All camcorders have a right grip strap for security

Always support your camcorder with two hands

23

25 STANCES FOR STABILITY

Keep stability foremost in your mind when shooting without a tripod. When standing, tuck your elbows into your chest for rigid support – this may be uncomfortable at first, but it will be worthwhile for the added stability. Keep your legs approximately shoulder-width apart, with your toes pointing outward slightly. Whenever possible, lean against a solid object, such as a wall or a fence, or brace your body against a doorway. For low-level shots, kneeling and sitting positions provide good stability for your camcorder. Alternatively, lie face down and support your camcorder on your camera bag.

TAKE A DEEP BREATH
For short shots that need a steady hand (for example, when shooting close-ups), inhale deeply and hold your breath. For longer shots, take slow, shallow breaths.

Brace your elbows against your chest for extra support

◁ USING A PROP
The back of a chair or the top of a table are ideal to prop your elbows on when shooting indoors. For shots taken outdoors, a garden wall or the hood of a car will serve equally well.

Position your knees around the back of the chair

BASIC STANCE ▷
This stance should be adopted for static shots taken at eye level. With your legs rigid and toes slightly splayed, place your feet about 12 in (30 cm) apart.

◁ **KNEELING**
*For steady low-level
shots, kneel down
on one leg and use
your raised knee
to prop up the
arm supporting
the camcorder.*

BRACE YOUR BACK ▷
*Sit back against a wall or a cabinet
to support your back. Steady the
camcorder on your knees.*

*Use a cushion to
provide extra
comfort*

▽ **LOW ANGLE SHOTS**
*Stretch out full length with your elbows
propped on the floor to shoot stable images
at ground level (use a cushion if available).*

26 WEAR COMFORTABLE CLOTHING

Whatever stance you adopt, you will be more comfortable if you wear clothes that do not restrict your movement. Certain projects and locations can cause a good deal of wear and tear on your clothing.

- Flat-heeled shoes are a practical choice when you need to be mobile.
- Many photography stores sell hard-wearing canvas jackets with pockets specially designed for conveniently storing your camera accessories.

27 USING STANDS

Using a tripod extends the range of subjects you can successfully cover. It allows you to zoom in on a subject without producing a shaky image and gives smoother pan and tilt shots. Some tripods have a built-in level, which ensures that the camera stays perfectly upright. A monopod is a more compact but less stable alternative to a tripod.

◁ **MONOPOD**
Place a hand on top of the camera to help stabilize the monopod. A monopod is ideal for static shots when shooting in confined spaces.

The height of the monopod can be altered

Brace the monopod by using your foot

A "fluid" head provides greater flexibility and allows smoother pans and tilts

Telescopic legs allow you to vary the height of your shots

Adjust the center column to add height

◁ **TRIPOD**
The adjustable legs allow the tripod to be leveled on uneven ground. The base of the legs are usually spiked or tipped with rubber to give a sure grip on a variety of ground surfaces.

28 BODY-MOUNTED SUPPORTS

Choose from a range of body-mounted supports to minimize the effects of camera shake while still keeping the freedom of movement that is restricted with fixed supports such as tripods and monopods.

■ With all types of body-mounted supports, conventional handheld movements can still be performed while sitting, standing, or kneeling.
■ Always secure body straps to help keep the camcorder from slipping.

The camcorder mounts onto an adjustable base

Attach the camera base to the top of the chest pod

A soft pad protects your body

Pockets for spare tapes and battery

SHOULDER HOLSTER △
This is an ideal body-mounted support for most compact camcorders. The weight of the camcorder is taken by your shoulder, and stability is provided by an extendable brace and a body strap. This model can be attached to a monopod for extra support.

CHEST POD △
For smaller camcorders, a chest pod is a lightweight option that will support your camcorder easily and comfortably. It is strapped around your neck to allow hands-free use, and it is particularly helpful during long shooting sessions.

29 WALKING WITH A CAMCORDER

Bend your legs and keep your body lowered while shooting on the move. This helps you maintain a low center of gravity, and avoids the rise and fall motion of normal walking.

- Choose a wide-angle lens position to minimize the effects of camera shake.
- Take short, steady strides and keep your footfalls as soft as possible.

Keep both eyes open as you walk

Tuck your elbows into your body

Bend your legs slightly as you move forward

FORWARD MOTION ▷
Concentrate on creating a slow, gliding feeling by taking short strides, keeping your feet close to the ground. Use this type of shot sparingly for tracking a subject that is on the move.

◁ CRABBING SHOTS
Swing one leg across the front of the other to move sideways. This shot is useful for tracking around a stationary subject to give a sense of depth.

Remember to keep your knees slightly bent

WATCH YOUR STEP
Keep both eyes open when taking shots on the move – this will enable you to scan ahead for obstacles in your path as well as keeping an eye on what is happening in the viewfinder. Take care when moving backward; make sure your path is unobstructed before proceeding.

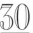

30 CRANE SHOTS

Use a crane shot for vertical moves up or down and to follow a subject. To begin the move, adopt a crouching position with your weight supported by your back leg and shoot a static opening hold. Slowly rise up to your full height, keeping the camcorder horizontal throughout the move. Hold the final frame for a couple of seconds. Reverse the procedure to follow a subject as it descends.

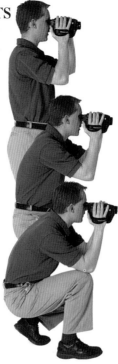

GOING UP ▷
Make certain that you are in a stable position for a steady opening shot. Keep the camera horizontal as you gradually straighten your legs and rise up to your full height.

CRANE ACTION △
Here, a crane shot was used to follow a child's progress up the ladder of a slide.

TRACKING WITH A CART

31 TRACKING SHOTS

For shots involving movement over a considerable distance, it is best to use some form of wheeled support, professionally known as a dolly, to keep the camera as steady as possible. A wheelchair or a shopping cart will serve the purpose adequately. Ask an assistant to push you along at an even pace, avoiding any jolts. Your own weight will help stabilize the steering. Brace yourself with your feet.

29

32 TRAVELING SHOTS

Shooting from the window of a car or a train is an excellent way to record images of landscapes and city streets. Shoot with the window open where possible (to avoid reflections and autofocus problems), but sit back to avoid being buffeted by the wind.

▪ Adopt a position with an oblique, three-quarter-angle view of the scene – a 90° angle will make details pass too quickly for the viewer to see.

SHOOTING FROM A CAR WINDOW

33 WHAT IS PANNING?

Panning is a horizontal move from left to right or vice versa, which imitates the movement of our heads as we scan the horizon. Pan shots are often essential for covering action sequences. They can also be used to scan subjects too large for one shot.

▪ Use a pan shot to redirect a viewer's attention from one subject to another, keeping the relationship between the two subjects clear.

▪ Compose static holds at the start and finish of the pan shot to allow the viewer time to absorb the scene.

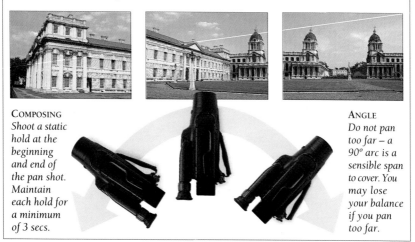

COMPOSING
Shoot a static hold at the beginning and end of the pan shot. Maintain each hold for a minimum of 3 secs.

ANGLE
Do not pan too far – a 90° arc is a sensible span to cover. You may lose your balance if you pan too far.

34 HOW TO TAKE PAN SHOTS

A tripod with a "fluid" head is ideal for achieving smooth pan shots. Spread the tripod legs wide apart and position yourself between two of them. Release the pan lock and frame the opening hold, then rotate the camera through an arc, bringing it to a gentle halt at the final hold.

- If you are panning without a tripod, select a wide angle setting to minimize shake.

△ USING A PAN HANDLE
Control the panning action by applying gentle pressure to the pan handle on your tripod – this will ensure a smooth panning movement throughout the entire shot.

HANDHELD PANS △
Without moving your legs, twist your body to face the start position. Shoot your initial hold and then slowly untwist your body until you are facing forward.

Sturdy legs give stability during pans

35 PACE YOUR PAN

As a rule, pan slowly and at an even pace to avoid jerks and to ensure that the picture does not appear blurred. Allow approximately five seconds for any object to cross from one side of the frame to the other – this will give your viewers ample time to absorb the details.

Rubber caps

36 WHAT IS TILTING?

Tilting the camcorder imitates the movement of our head when we scan a subject from top to bottom or vice versa. It is basically a vertical pan shot. Tilts can be used to follow vertical motion or to convey to the viewer a sense of the scale of a tall object. As with panning shots, a static hold should be used at the beginning and end of a tilt to give the viewer enough time to register the subject.

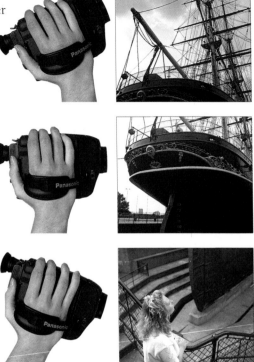

A SENSE OF HEIGHT ▷
Here, a shot of a woman gazing upward sets the scene before the camcorder is tilted upward to follow the direction of her gaze. The tilt action conveys the great height of the rigging.

37 TIPS FOR SUCCESSFUL TILTS & PANS

Carefully planned tilts and pans can add a professional touch to your home video, so always decide exactly where you are going to hold the image before you begin shooting. If possible, practice the movement a few times before shooting and always move slowly so that the viewer has sufficient time to absorb the subject.

- Gauge your pan and tilt speeds by allowing about five seconds for the subject to pass from one side of the viewfinder frame to the other.
- Never reverse pans – scanning back and forth across the same scenery.
- Never stop recording in the middle of a pan or tilt sequence or you will create a clumsy and abrupt edit.

38 HOW TO TILT

Begin by pointing the camcorder downwards, holding the original image for about three seconds. Lean back slowly, so that the camcorder pivots smoothly through a vertical arc. Again, hold the final image for three seconds. Reverse the procedure to record a shot that tilts down.

Do not tilt more than 90°; you may lose your balance

Pan handle

◁ **TILTING WITH A TRIPOD**
Stand between the legs of your tripod, release the tilt lock, and compose your first image. Apply only a gentle pressure to the pan handle to begin the tilt, and bring the movement to a gentle halt to hold the final image.

△ **LOW LEVEL TILT**
For lower level tilts, kneel down on one leg and support your elbow on your raised knee. This position will help give a steady image at the beginning or end of the tilt action. Always support the base of the camcorder with your left hand to increase image stability throughout the tilting sequence.

Splay the tripod legs wide apart

Place your feet between the tripod legs

39 HOSING

Continuously panning and tilting across a subject in an effort to cover it all will only confuse and irritate a viewer. This erratic "hosing" movement is a common fault with newcomers to video. It is far better to break the subject into more than one shot or to set the zoom lens to a wider angle.

USING ZOOM

40 THE ZOOM FACILITY

Use the zoom lens to make your subject appear larger or smaller in the viewfinder without changing the camera position. Zoom in to show increasingly magnified detail of your subject; zoom out to reveal a progressively wider angle. The zoom action is controlled by a rocker switch on the top of your camcorder.

Activate the zoom motor by applying pressure to the rocker switch on top of your camcorder

41 CONTROLLING THE ZOOM

Always be wary of zooming in or out too frequently while shooting; the "trombone" effect will be tiring and uncomfortable for your viewer. As a rule, not more than one in five shots should involve zoom action.

- The zoom should be used mostly as a cropping device, to adjust the size of the subject in the viewfinder before you actually begin shooting.
- Make subtle zoom adjustments to accommodate your subject's action.

WIDE ANGLE OF VIEW
Zoom out to reveal a wide-angle view of your chosen subject. Here, the subject can be viewed in relation to its surroundings.

TELEPHOTO VIEW
Zooming in shows a progressively magnified view of your subject, but note that the angle of view is much narrower.

42 THE STANDARD RANGE OF SHOTS

Familiarize yourself with the standard range of shots used in the television and film industry – they are extremely useful when you are planning your video. Although the shots are defined in terms of human figures, they apply to all subjects.

■ Whatever shot you choose, always compose the elements carefully, and be sure to avoid shots that cut people off at the joints (see p.42).

■ Zooming in slowly from a long shot to a close-up has the effect of leading the viewer toward your subject.

LONG SHOT
A long shot (LS) contains the full human figure. It is often used as an establishing shot, showing subjects in their environment.

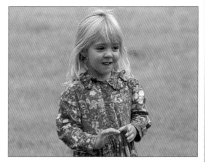

MIDSHOT
Introduce an individual while maintaining a sense of background by using a midshot (MS), which cuts off just below waist level.

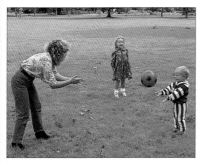

CLOSE-UP SHOT
Use a close-up (CU), which is a head-and-shoulders shot of an individual, to create a feeling of intimacy with your subject.

BIG CLOSE-UP SHOT
A big close-up (BCU) – usually just cutting through the subject's chin and forehead – creates a strong visual impact on TV screens.

43 ZOOMING IN

Zoom in to direct your viewer's eye toward an important element within a wider shot. You can also employ zoom to emphasize an emotionally charged moment, for example, zooming in to show a newborn baby cradled in its mother's arms.

CLOSE-UP VIEW ▷
Zoom in to a close-up in order to emphasize the strong bond of affection between the little girl and her pet.

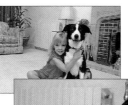
◁ WIDE-ANGLE VIEW
Begin with a wide-angle view to establish the setting and to introduce the girl and her dog to the viewer.

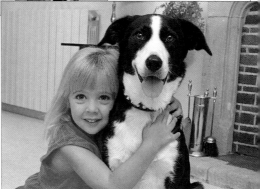

44 ZOOMING OUT

Zoom out to reveal the context in which your subject is placed. The movement can add an element of humor or drama if the setting is unexpected – a child's smile appears innocent, until you zoom out to reveal clothes and toys strewn everywhere.

WIDE-ANGLE VIEW ▷
By zooming out to include the bear, the reason for the child's happiness is revealed and the audience's curiosity is satisfied.

◁ CLOSE-UP VIEW
A close-up view lets us enjoy the child's happy expression and arouses our curiosity as to the cause of her delight.

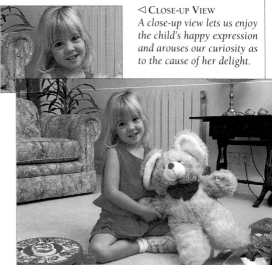

45 SHOOTING HOLDS DURING A ZOOM

Shoot a static hold at the start of your zoom shot so that the viewer has ample time to absorb the subject matter (approximately two seconds).

After you have completed the zoom movement, hold the final image for a similar period of time to allow the viewer to register the revealed setting.

OPENING HOLD
Hold the opening shot for a couple of seconds while the child begins to open the gift.

ZOOMING OUT
Zoom out slowly and let the viewer share in the thrill as the child unwraps her gift.

FINAL HOLD
Hold the final shot for two or three seconds to let your audience absorb the scene.

46 THE ADVANTAGES OF MANUAL ZOOMING

Vary the speed of your zoom by using the manual override facility (if you have it). This allows rapid "crash zooms," which are ideal for simulating shock or surprise.

- On most camcorders, the speed of the zoom is determined by the motor.
- Manual zoom movements are often less smooth than motorized ones.
- If possible, practice before shooting.

FOLLOWING THE ACTION
Use a wide-angle view to follow the action and anticipate drama as a wave approaches.

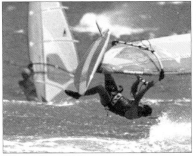

"CRASH ZOOM" MOVEMENT
Zoom in rapidly to accentuate the dramatic action as the windsurfer becomes airborne.

COMPOSING YOUR VIDEO

47 CAREFUL COMPOSITION

Remember that the rules of composition apply as much to the framing of a video shot as they do to photography, which deals exclusively with still images. Always try to balance the various elements in your frame, and consider each shot in relation to the one following it – visual variety is crucial with video.

A WELL-BALANCED STATIC COMPOSITION

MAIN SUBJECT POSITIONED OFF-CENTER

48 THE RULE OF THIRDS

Do not always feel obliged to place your main subject in the center of the frame. Imagine that your frame is divided equally by two horizontal lines and two vertical lines. The four points where these lines intersect are frequently the best places to position the most important elements in your composition.

49 FILLING THE FRAME

Including too much irrelevant background detail is an oversight that is commonly made by newcomers to video. The easiest way to draw your audience's attention to your chosen center of interest is to make it large in the frame. Bear in mind the fact that a moving subject, no matter how small, will distract the viewer's attention away from a static subject.

LITTLE INTEREST △
Here, the main subjects are too small in the frame.

CLOSE-UP ACTION ▷
The excited expressions that are now visible in this shot greatly enhance the picture.

THE SECRET GARDEN
Glimpsing this formal garden through an archway in a brick wall arouses our curiosity as to what lies beyond the wall. Plus, the arch is a feature in its own right.

50 HOW TO USE FRAMES

Although as a video maker you are always restricted to the fixed horizontal format of a TV screen, you can still create some visual variation by using foreground frames.
- Framing your subject in a doorway or a window is a commonly used device.
- Frames positioned behind your subject can be used to produce a more subtle effect.
- Frames can reinforce the emphasis on your subject.

51 CHANGING YOUR POINT OF VIEW

Create interesting variations in your videos by composing shots from different angles. In the images below, unusual viewpoints and foreground interest help create a sense of depth.

- Compose shots from low angles by lying on the floor or kneeling.
- Compose shots from high angles by standing on a chair or holding your camcorder above your head.

HIGH VIEWPOINT

LOW VIEWPOINT

52 FRAMING & MOVEMENT

Compose pictures of moving subjects so that there is more space in front of them than there is behind; otherwise, your subject will appear to push the edge of the frame along.

- Begin panning as the subject enters the frame and continue panning at a constant speed through an arc.
- To end the shot, stop panning and let your subject move offscreen.

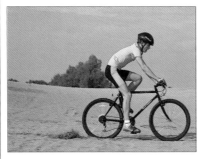

CLOSE TO THE EDGE

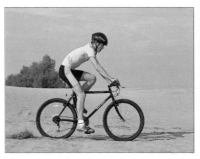

ROOM FOR FORWARD MOTION

53 DON'T LEAVE TOO MUCH HEADROOM

When taking shots of people, do not leave too much space above the top of your subject's head; this will create an uncomfortable and unbalanced composition. Tilt the camcorder downward to include more of your subject and zoom in a little farther to fill more of the frame.

△ OVER THE TOP
Too much headroom creates an unbalanced composition.

PERFECT PORTRAITURE ▷
Here, the subject is more prominent in the frame and the composition is pleasing.

54 AVOIDING CLUTTERED SURROUNDINGS

Do not shoot a subject when it is surrounded with distracting clutter. Take the time to move away any objects that are not relevant, or reframe the shot at a different angle. Be sure to check the background for objects, such as lampposts, that may seem to be attached to your subject.

CLUTTERED SURROUNDINGS

UNCLUTTERED COMPOSITION

55 LEAVE YOUR SUBJECT ROOM TO VIEW

Take care when shooting static shots of people. Frame your shot so that there is more screen room in the direction that the person is looking than there is behind. The result will be comfortable and logical for the viewer, reinforcing the direction of your subject's gaze.

△ No Looking Space
In this image, the subject is given no looking space.

Room to View ▷
This composition is far more pleasing – the looking space reinforces the child's gaze.

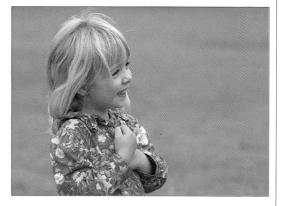

56 DON'T DISSECT YOUR SUBJECT

Avoid framing shots that cut people off at the joints – you risk creating the effect of disembodied heads or footless figures.

▪ With long shots, always allow some headroom; otherwise, the figure will seem crushed by the top of the frame.
▪ Avoid leaving too much headroom.

UNBALANCED COMPOSITION

BALANCED COMPOSITION

CONTINUITY

57 HOW TO RETAIN A SENSE OF DIRECTION

Shoot consecutive shots from the same side of an imaginary "line of action" to retain a sense of continuity of screen direction. By staying on one side of the "line" you can link shots that are taken at different locations.

MOVEMENT FROM LEFT TO RIGHT

SCREEN DIRECTION MAINTAINED

58 THE IMPORTANCE OF CONTINUITY

The "line of action" is part of a complex language of film and video making. Unintentionally crossing the "line" will confuse your viewers by making them think that your subject has changed direction inexplicably.

SETTING SCREEN DIRECTION
Here, the screen direction is established from left to right across the camcorder frame.

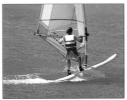

CONTINUED ACTION
Continuity is preserved as long as the windsurfer keeps traveling from left to right.

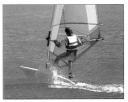

REVERSED ACTION
Crossing the line of action changes the screen direction and confuses the viewer.

43

59 HOW TO CHANGE SCREEN DIRECTION

Overcome the problem of reversing screen direction (whereby your subject appears to be moving in the opposite direction from one frame to the next) by shooting a neutral shot directly along the line of action taken by your subject. The neutral shot, in which the subject moves directly toward or away from the camera, effectively acts as a bridge between consecutive shots taken from opposite sides of the line of action.

■ Changes of screen direction can also be disguised by inserting a cutaway shot (see p.56) that is related to the main subject.

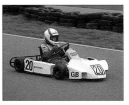

LINE OF ACTION
Here, the line of action is the race track and the car is shown moving from left to right across the screen.

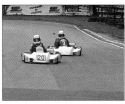

NEUTRAL SHOT
Bridge a change in direction with a shot showing the cars racing directly toward or away from the camera.

NEW DIRECTION
The next shot, taken from the opposite side of the track, establishes a new screen direction from right to left.

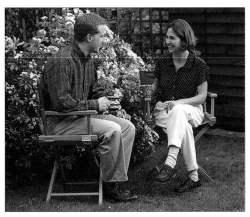

A CONVERSATION PIECE

60 A SENSE OF SPACE

When shooting a video of two people talking to one another, always include an initial long shot to establish the spatial relationship between them. You must remember to retain a sense of your subjects' spatial relationship when you are recording close-up shots of individual subjects, or else your audience is likely to become confused.

61 FOLLOWING THE EYELINE RULE

When shooting two successive shots of two people talking to each other, show them looking in opposite directions by taking both shots from one side of an imaginary line along the axis of their gaze. If you cross this line, it will appear as if your subjects are ignoring each other.

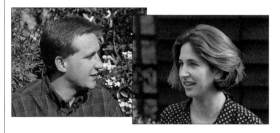

THE CORRECT EYELINE
Watching these two shots, the audience is given the impression that the subjects are relating to each other quite naturally. This is because both shots have been taken from the same side of the eyeline.

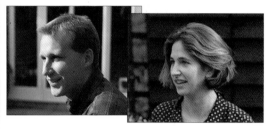

NOT SEEING EYE TO EYE
Here, the audience is given the impression that the two subjects are ignoring each other – one appears to be talking to the back of the other's head. This is because the camera position has crossed over the eyeline.

62 MATCHING REVERSE ANGLES

Make sure that reverse angles always match each other. Even when there are two figures in the same shot *(see below)*, retain the sense of spatial relationship by keeping the camera on the same side of the eyeline.

REVERSE ANGLES
The first shot (near right) establishes the position of the eyeline between the two subjects. When reversing the angle to show a frontal view of the child (far right), the camera must stay on the same side of the 180° line to avoid confusing the viewer.

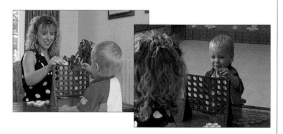

 ## 63 USING COMPLEMENTARY ANGLES

Reinforce the sense of spatial relationships between subjects by using "complementary" angles. A low-angle shot of a person looking down can be complemented by a high-angle "point-of-view" shot.

◁ **LOW VIEWPOINT**
This close-up was shot from a low angle to help the viewer identify with the child.

COMPLEMENTARY SHOT ▷
A shot of the book taken from the child's eye level complements the preceding shot.

64 MANIPULATING REALITY WITH EYELINES

When your subject looks off-screen, your audience expects the next shot to reveal what the person sees. Exploit this convention to create the illusion of interaction between subjects that are unrelated in reality.

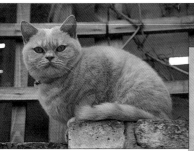

◁ **CAT STARE**
In reality, the cat is staring directly at the lens of the video camera.

COMPLEMENTARY SHOT ▷
Shooting the child from a complementary angle tells us that this is what the cat sees.

65 A SENSE OF TIME

It is crucial that you develop a sense of the appropriate length of time that each shot should remain on the screen. With static shots of stationary subjects, the duration of a shot should be determined by the amount of information that your audience needs to absorb.

- As a rule of thumb, the wider the shot and the more detail it shows, the longer it needs to stay on screen.
- Generally, allow a minimum of three seconds for any one shot.

ESTABLISHING A SCENE
Hold shots of new subjects for approximately seven seconds, depending on the amount of detail that your audience needs to absorb.

LONG SHOT
Long shots taken of a static subject should be held for about five seconds.

MIDSHOT
A closer shot can be shorter still – your audience will be bored if you linger too long.

CLOSE-UP SHOT
Hold details for about four seconds – but cutting too soon will irritate viewers.

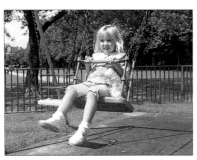

GETTING INTO THE SWING

66 CONTINUOUS ACTION

Static shots that involve continuous cycles of motion (*see left*), should be held long enough for the cycle to be repeated (at least once) and cut at the end of the cycle to avoid an awkward cut (*see p.48*). Static shots showing continuous activity or slow-moving subjects are held for 50 percent longer than stationary subjects.

67 THE RIGHT TIME TO CUT

Recognizing the right point to cut is a matter of using common sense to judge the extent to which a subject will sustain the interest of your audience. Holding a shot of a child's first birthday cake for more than ten seconds will weary even the most devoted grandparents. But by the same rule, constantly flitting from shot to shot without allowing time for a scene to be absorbed will frustrate your viewer. The worst cut, however, is ending an action shot before it is completed (see below).

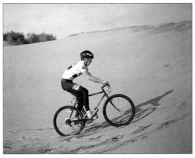

HEADING FOR A FALL
The initial framing sets the scene as the cyclist races across the screen toward the sand dune that will cause his downfall.

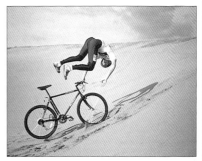

HEAD OVER HEELS
To cut here would be disastrous. The viewer would understandably be frustrated to miss the outcome of the dramatic incident.

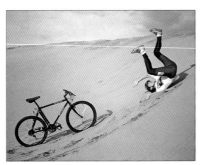

COMING BACK DOWN TO EARTH
Cutting at this point is more acceptable but would still leave the viewer concerned about the rider's well-being after his accident.

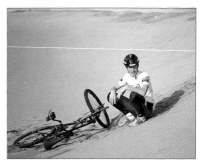

NO HARM DONE
Now the action is really over. Cutting here is ideal. However, holding this frame for too long would lessen the impact of the shot.

SOUND ADVICE

68 BASIC SOUND RECORDING

Remember that every time you press the record button, you automatically record sound as well as images. Most camcorders come equipped with an omnidirectional mike – a mike that picks up sound from all around. It will, of course, also pick up handling noises as you operate the control buttons.

SILENT MOVIES ▷
Keep handling noises to a minimum by taking the time to learn the position of all the control buttons.

◁ HEADPHONES
If possible, use headphones to monitor sound recordings.

RECORDING SOUND INDOORS
Choose your recording position carefully. Ambient noise can enhance your video under certain circumstances, but don't let background noise drown your subject.

69 INDOOR ACOUSTICS

When taking shots indoors, always remain alert to the effect of acoustics on the quality of sound. For improved sound quality, move your camcorder as close to the sound source as possible. This may involve choosing a wide-angle lens setting, and adjusting your shot as necessary.
- Carpets, cushions, and curtains tend to deaden sound. Harder surfaces – such as walls and glass – reflect sound, creating reverberation and echoes.
- Avoid recording in bathrooms, corridors, and the corners of rooms.

70 RECORDING OUTDOORS

The wind can be a problem when recording outdoors. Look for a shooting position where your mike will be shielded from the wind, such as adjacent to a tall fence or a wall.

■ Always use a foam windshield when shooting videos in windy conditions.
■ Reduce background noises, such as aircraft and road traffic, by using a directional mike *(see p.51)*.

FOAM
WINDSHIELD

SHIELDING THE MICROPHONE △
A tree can act as a useful windbreak when taking outdoor shots. Garden walls, which are useful for stabilizing a camera (see p.25), are also effective shields from the wind.

71 TESTING YOUR MICROPHONE

To produce successful sound recordings with your camcorder, you must be aware of the capabilities of your built-in mike. Check a mike's effectiveness with this simple test.

Ask a friend to read aloud while you record. Begin at 3 feet (1 m) away and then back off, recording at 3 feet intervals. Play back to check the maximum distance for audibility.

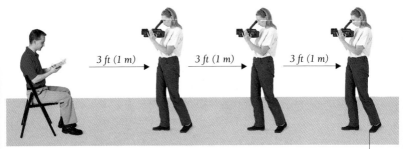

3 ft (1 m) 3 ft (1 m) 3 ft (1 m)

CHECK YOUR DISTANCE
Make a note of the maximum distance you can be from the reader before sound is indistinct.

Step backward from the reader in 3 feet (1 m) stages to test your microphone

72 AUXILIARY MICROPHONES

Once you have mastered the basic skills of sound recording, you can overcome the limitations of your built-in microphone and extend your creative potential by using various auxiliary microphones.

CAMCORDER-MOUNTABLE MICROPHONES
Plug a camcorder-mountable mike into your camcorder's sound socket to override the built-in mike and reduce interference caused by handling noises. Different microphones are designed to be effective for many different circumstances, according to their predominant angle of sound acceptance (see p.13).

HANDHELD CARDIOID MICROPHONES
Cardioid mikes have a narrower angle of acceptance than omnidirectional mikes – they are more sensitive to sounds coming toward the front or sides of the mike than to sounds from behind. A handheld cardioid mike is popular for use in interviews, where it can be directed between the speakers.

CLIP-ON MICROPHONES
Tiny clip-on mikes are omnidirectional mikes that are ideal for interview situations. As its name suggests, this mike clips onto a tie or a scarf, or indeed any clothing above chest height. The microphone cable can be discreetly hidden away among clothing. In order to avoid distracting rustling or muffling of sound, make sure that the mike does not rub against clothing.

UNDERSTANDING LIGHT

The light attaches to a "shoe" on top of the camera

SUNGUN CAMCORDER LIGHT

73 SUNGUNS

Attach a small, low-wattage light to the accessory shoe on top of your camcorder to provide fill-in lighting in areas of shadow.

- A sungun gives a narrow beam of light over a limited area, so use it to illuminate close-up shots.
- Some accessory lights can swivel to bounce light off the ceiling.
- Battery life is generally just 20 minutes, so carry plenty of spares.

74 HANDHELD LIGHT

Although not as convenient as a sungun, handheld lights provide a more powerful and highly flexible alternative. They can be angled at about 45° from the axis of the lens to give a modeled effect that is often more pleasing than that from harsher sungun lighting.

- Handheld lights can provide the main source over a wide area for full-length shots of people.
- For flexibility, ask a friend to hold the light – it should be held above the lens, angled down.

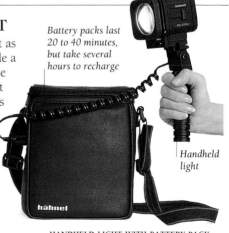

Battery packs last 20 to 40 minutes, but take several hours to recharge

Handheld light

HANDHELD LIGHT WITH BATTERY PACK

75 FREESTANDING LIGHT

Electrically powered video lights produce a strong flood of light over a wide area.

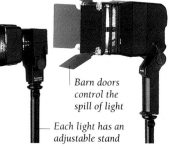

- With some video lights, you can adjust the beam from a wide "flood" to a narrow "spot." Use the "barn doors" to control the spread of light.

Barn doors control the spill of light

Each light has an adjustable stand

◁ **EVEN LIGHTING FOR GROUP SHOTS**
Set the lights high, at about 45° to the lens, far enough away to give even illumination.

FREESTANDING BACKLIGHTING ▷
Position a light behind your main subject to separate figures from the background.

76 DIFFUSING LIGHT

Diffuse your light source to produce a softer, more natural and even quality of illumination.

- Some lights incorporate built-in diffusers, but diffusion works best if there is some distance between the light source and the diffuser.
- Improvise diffusers by placing tracing paper or even a white sheet in front of a light. But never put flammable material too close to lights – they can be very hot.

USING A DIFFUSING SHEET
Use a diffuser sheet on the barn doors, bowed away from the light, to provide softer lighting.

77 REFLECTED LIGHT

If you do not have a diffuser on hand, try bouncing light off a white wall or ceiling to produce a more even spread of light than direct lighting.
- If the reflector surface is not white, your subject may have an unnatural color cast.
- Natural window lighting can be reflected back to your subject using strategically positioned white cardboard.

WINDOW LIGHT REFLECTED FROM THE PAGES OF A BOOK

78 IMPROVISED LIGHT

For indoor shots when there are no outlets or battery-operated video lights available, improvise by using existing domestic facilities.
- Angle desk lamps to direct light toward particular areas of a room.
- Open doors and hatches to allow light to spill in from adjacent areas.
- Use high-wattage bulbs in lamps.

AN INDOOR PARTY SHOT

79 SAFETY TIPS

Always make safety your first consideration when using electricity.
- Photoflood bulbs become very hot so do not cover them in any way – shades could easily melt and burn.
- Handle video lights with care – use garden gloves when adjusting barn doors when they are hot.
- Always turn lights off when moving them; this will preserve bulb life.
- Allow units to cool down before you pack them away for storage.
- Coil light cables loosely and tape them securely to the floor whenever possible to avoid accidents, especially when there are children around.
- Take the time to weigh down the bases of lamp stands securely with sandbags to avoid tripping.
- Make sure that you never overload domestic lighting or power circuits.

EDITING

80 HOW TO EDIT YOUR VIDEOS

With a little careful planning, editing can be carried out at the time of shooting, but the shot lengths and, consequently, the program will be fixed. More advanced editing can be achieved by recording material from your original tape onto another tape using an edit VCR. All you need is your camcorder, a VCR, and a TV set, with the relevant connecting wires.

1 Once the edit tape has been loaded into the VCR and set to pause/record, run the original material on your camera until you find the start of the first shot you require. Put the camera in pause mode.

2 Release the pause button on both of the machines at the same time and the VCR will start recording the selected section. Keep your finger poised over the pause button, ready to stop recording.

3 Watch the TV monitor until you come to the end of the section you wish to record – the "edit out" point – then press the pause to stop recording. Now you can repeat the process to record the next shot.

81 TAPE-TO-TAPE TIPS

In preparation for editing, list all the shots on your original tape and use it for reference.

- The TV set should be tuned in to the usual video channel. It can be used as a monitor for both your camcorder and the VCR machine.
- Every video machine needs to backspace each time you pause the recording, so bear in mind that you will always lose about one second at the beginning and end of each shot.

82 HOW TO EDIT USING CUTAWAYS

Use cutaway shots in your edit to link two shots that are related but which occurred at different times. A cutaway shot is effectively a bridge between two periods of screen time. They are often used to condense events that would weary the viewer if shown in their entirety. However, the cutaway must remain somehow related to the main subject in order for it to make sense to your audience.

■ Two or more cutaways together are a useful device – they suggest the passage of a longer period of time.

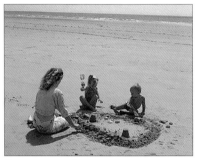

ESTABLISH THE SETTING
A long shot establishes the subject and the setting. The audience must be allowed time to absorb the atmosphere of the video.

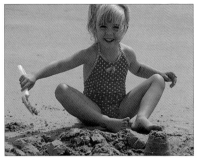

CHILD'S PLAY
Continue the sequence with a close-up shot of a child. The viewer can now see that the child is starting to build a sandcastle.

A SHORT CUT TO THE SEA
To avoid showing the building process in its entirety, cut away to the encroaching tide – will there be time to finish the sandcastle?

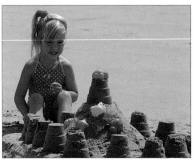

ALL MY OWN WORK
Now you can cut back for the final shot, which is another close-up of the triumphant little girl with her completed sandcastle.

83 HOW TO EDIT USING CUT-INS

Cutting in is a useful device if you are recording an event that is too long to show in its entirety.

▪ Give the impression of time passing by cutting from a wide shot to show close-up details from the scene. The cut-in must be instantly recognizable as part of the wider scene in order for it to make sense to your viewer.

▪ Cut-ins can be used to give your viewer more information about a scene – cutting to an inscribed cake during a party shot could tell us that we are watching a birthday party.

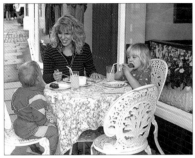

OUT TO LUNCH
Begin a sequence with a long shot that establishes the scene. Here, a mother and her two children enjoy lunch at a café.

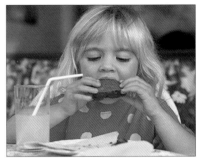

CUTTING IN TO A CAKE
Show time passing by cutting-in to a detail of the girl. Cut-ins can be useful for giving extra information about a scene.

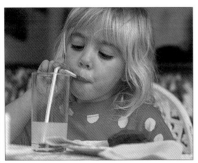

AVOIDING JUMP CUTS
Be careful to avoid turning the camcorder off and on while keeping it in the same position, or you will create ugly jump cuts.

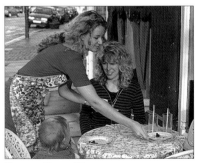

TIME TO CLEAN UP
You can now cut back to a wide shot of the end of the meal, and neither the participants nor the viewer need have more than their fill.

84 USING FADES AND WIPES

Use the fade facility (if you have it) to link separate shots without resorting to awkward and irritating jump cuts. Fades can indicate time passing when you have no suitable cutaways or cut-ins to do the job.

■ Fades can be used to mark the end of sequences shot in a single location or covering a single subject matter.

■ Wipes provide an alternative visual transition to link subjects. The end of one shot is frozen as a digital image, which is stored in the camcorder's memory. This image is then replaced by a new shot of live action, which gradually appears by being smoothly "wiped" across the screen from one side to the other.

COUNTRY COTTAGE
The final shot of a scene shot in the countryside is frozen.

EXIT COTTAGE
A new live shot appears to cross from right to left.

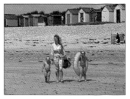

ENTER THE BEACH
The new beach location now fills the screen entirely.

85 THE ADVANTAGES OF EDIT MACHINES

For more precise editing it is worth purchasing an edit controller. This invaluable machine affords you maximum control throughout each stage of the editing process.

■ Edit controllers have a single set of controls to command the editing functions of both the player and the recording machine.

■ Use your edit controller to preview each edit before you actually record (and change the edit point if you are not satisfied with the final result).

■ Some edit controllers allow you to introduce digital special effects.

■ The ideal setup comprises a basic VCR as a player, linked via the edit controller to another, more advanced VCR. Ideally, each VCR should have a TV monitor to compare edit points.

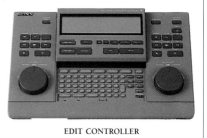

EDIT CONTROLLER

86 SHOOTING TO EDIT

Once you have mastered the basics of tape-to-tape editing, you can start to think ahead and take shots with the editing process in mind.

Although the sequence below consists of six shots showing the fire engine passing by, it is actually three shots combined by editing after the event.

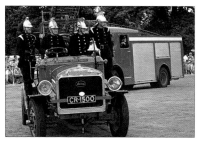

FIRST SECTION OF INITIAL LONG-SHOT PAN

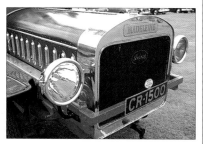

FIRST SECTION OF DETAIL SHOT TAKEN LATER

LOW-ANGLE VIEW FROM THIRD POSITION

SECOND SECTION OF INITIAL LONG-SHOT PAN

SECOND SECTION OF DETAIL SHOT

THIRD SECTION OF INITIAL LONG-SHOT PAN

WEDDINGS

87 PLANNING YOUR VIDEO

Careful planning is the key to a successful wedding video. List of all the events you want to include in your video, and then plan each shot carefully. Assess where you will require freestanding lights, with battery packs or electrical outlets; where you will need a tripod; and where you will use filters.

- You will have to travel between locations, so visit each one in advance, and make a note of the time taken for each journey.
- Make sure you have permission to shoot.
- Attend the rehearsal for the ceremony and take test shots from various locations.
- Check the acoustics at the site. Clap your hands to test for echoes (*see p.49*).

LIST OF SHOTS
Compile a shot list so that you are prepared for each event. The above example covers the bride's arrival.

88 OPENING SHOTS

Add a professional touch to your video by using still photographs for the opening shots. Pin the photographs to a wall or a board and, for best results, use a pair of video lights set at an angle of 45° to the photos to attain an even spread of light.

- Use the macro capability on your camera lens to show small-scale details of photographs or to include the wording of the invitation.

Use confetti and flowers to add color

PHOTOS & FLOWERS
To help set the scene for the wedding, include shots of the invitation and still photographs of the bride and groom from family albums.

89 THE BRIDE'S PREPARATIONS

Shoot the initial sequences of the bride preparing her hair and her makeup in readiness for the big event. A double image of the bride and her reflection in the mirror can produce an elegant shot. Finish with a shot of the bride leaving her home.

■ Include shots of decorations being set out at the reception area and the flowers being arranged.
■ The antics of children can provide a welcome element of humor.
■ Edit between the various shots to help create an air of expectation.

◁ HERE COMES THE CAKE
The arrival of the wedding cake at the reception area is usually a high point in the preparations for the big day.

FLOWER ARRANGING ▷
Flowers always add color to your shots, so insert shots of flowers being arranged into the preparation sequences.

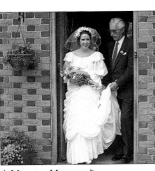

◁ THE FATHER OF THE BRIDE
Make sure that you get a good shot of the bride leaving her old family home, escorted by her father.

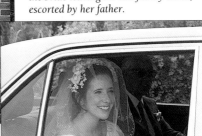

A MOVING MOMENT ▷
Wrap up the sequence with a low-angle shot of the bride in the bridal car as it prepares to leave for the ceremony.

90 COVERING THE WEDDING CEREMONY

Ideally, try to set up a frontal or three-quarters view of the couple with the congregation behind them. Place your tripod at a distance that is far enough back to get a full-length shot of the couple when the lens is in the wide-angle position. You can then use the telephoto facility to take close-ups of the couple and shots of the reactions of family and friends.

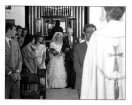

THE ARRIVAL OF THE BRIDE
You will need to ensure that the official's back does not obscure your view of events.

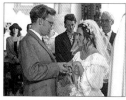

THE HAPPY COUPLE
From the initial wide-angle position, tighten up to a mid-shot to include some guests.

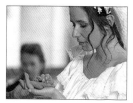

EXCHANGING RINGS
Tighten to a close-up shot of the bride and groom as they exchange rings.

91 CANDID SHOTS OF FAMILY & FRIENDS

Use your telephoto lens to take candid shots of family and friends at the reception. Find a camera position that gives you a clear view of events, close enough to the head table to give good sound quality for the toasts. Use manual focusing to single out individuals within groups.

FRIENDLY FACES
Build up sequences of shots of friends as they chat informally and admire the bride's dress.

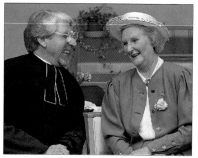

CANDID PORTRAIT
Ask a family member to point out any of the guests who may be offended if omitted.

VACATIONS

92 RELAXING ON THE BEACH

Take time to compose wide-angle views of beaches. Get up early to capture the warmth of the rich morning light and the feeling of calm. Shooting in the afternoon will allow you to record beach activities that will enliven the mood of your video.

■ Many vacation videos fail because they lack structure. Try to develop a theme for your video or introduce a story line to tie shots together.

■ Create viewer interest by varying the content. And always be sure to include shots of people in your video.

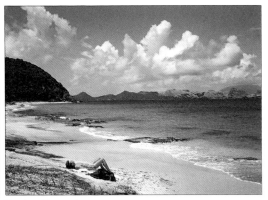

LIFE'S A BEACH △
Here, a single figure on a vast stretch of otherwise deserted coastline sets a vacation mood of peace and tranquillity.

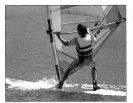

A CHANGE OF PACE △
A passing windsurfer adds a dash of color and action. Such shots can provide a welcome change of pace in your vacation video.

PLANNING YOUR VACATION VIDEO
Whatever type of vacation you choose, your video will always benefit from a little forethought. Plan ahead as much as possible by studying travel guides and brochures so that you have a clear idea of the subjects you are likely to want to shoot. You might be able to discover a suitable theme for your vacation video before you even leave home.

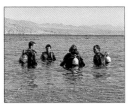

OUT TO SEA △
A group of scuba divers set off to explore the depths. A tripod was used to keep the horizon line level.

93 RECORDING TOWN LIFE

Get to know a town before attempting to capture its atmosphere on video. Take time to stroll around without your camera, making notes of worthy subjects. Establish which time of day gives the best lighting for major buildings and statues.

■ Plan opening and closing shots for each sequence and link the various elements. A simple device is to shoot a person looking toward a subject before shooting the object of their interest. Use shots of street signs to take the viewer to a new location.

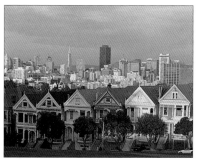

AN OVERVIEW OF THE TOWN
A wide-angle shot of the town from a high viewpoint serves as an introduction for the viewer. A wide-angle converter is useful.

INFORMATIVE DETAIL
Detail shots taken using a long focal length add flavor to your sequence. Here, give your viewer ample time to read the words.

TAKE A TOUR
A good way to see a larger town is to take a bus, tram, or trolley – guided tours are interesting, and so is the bus itself.

THE CITY AT NIGHT
Your video is able to cope with cityscapes at night. Illuminated street lights, traffic lights, and neon signs can transform a town.

94 BUILDINGS MADE EASIER

A wide-angle converter is invaluable when shooting buildings. It helps you avoid the necessity of using too many pan shots. Zoom in to include architectural details.

- Lighting is a crucial element when shooting buildings. Avoid shooting at midday when the sun shines directly overhead – architectural details will be obscured by heavy shadows.

△ OVERCAST LIGHTING
An overcast day emphasizes detail. Slanting sunlight highlights a building's form.

ARCHITECTURAL DETAIL ▷
Zoom in to compose shots of architectural details.

95 TRAVELING TIPS

Always take precautions when taking your expensive camcorder equipment abroad.

- Camcorders are a target for thieves – make sure that you insure your equipment fully.
- Although x-ray machines and metal detectors will not damage videotapes, be wary of the large electromagnetic machines used at airports. If in doubt, ask for your cases to be hand-searched.
- When traveling by air, carry the equipment as hand luggage in a strong protective case.

BATTERY CHARGER

BATTERY

ELECTRICAL ADAPTOR

ELECTRICAL EQUIPMENT △
Adaptors may be required for plugs when you are traveling abroad. Most battery chargers can be adjusted to suit local voltages.

SPORTS

96 CAPTURING THE ACTION

The position of the camera is a vital element when recording sports. For team games, such as football or basketball, choose a high viewpoint near to the center line and use pan shots to follow the movement of play. Use a tripod to ensure steady close-up shots while covering detailed action.

△ HIGH VIEWPOINT
Some sports naturally lend themselves to the use of unusual and scenic viewpoints.

△ COURSE EVENT
Course events can only be covered in part. Use spectator reactions to bridge shots.

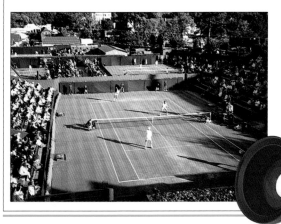

◁ CROSS-COURT SHOTS
Cover court games from just one end of the playing surface using a wide angle. Gentle pans can be used to keep up with the action as it moves from side to side.

▽ EXTRA COVERAGE
Here, a wide-angle converter was used to help keep the entire tennis court in the frame.

97 SHOOTING IN THE RAIN

WATER-RESISTANT HOUSING

In light rain, or anywhere with a danger of spray from water or from snow, use water-resistant housing to protect your camcorder against moisture, which can ruin your equipment. The housing will allow you to take action shots from spectacular angles.

■ Waterproof housings are available for scuba divers and snorkeling enthusiasts.

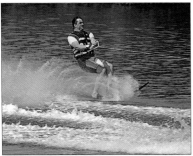

KEEPING UP WITH THE ACTION
With a powerful zoom you can follow some watersports from the safety of the shore.

SHORE SHOT
When shooting from a beach, remember that sand and spray can ruin your camcorder.

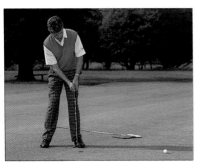

LOOK & LEARN
Use your camcorder to scrutinize the most crucial aspects of your favorite sport.

98 SPORTS ANALYSIS

Use your camcorder to analyze your golf swing, your diving posture, or your tennis shots. Whatever your sport, a video can help you recognize your strengths and weaknesses.

■ Use a tripod and compose a shot that encompasses all of the action.

■ High shutter speeds are ideal when recording faster activities. Study the slow-motion replays on your VCR.

■ Always use well-lit conditions when using fast shutter speeds.

ANIMALS

99 PETS

Taking shots of pets is a good starting point for recording animal behavior. Familiarity with your pet's habits will help you capture their most entertaining traits. Dogs are particularly good subjects because they respond to commands. Film your cat while it is playing with its favorite toy.

■ Where possible, shoot from the subject's eye level. With smaller animals, you will need to adopt a very low camera angle *(see p.25)*, or else raise the subject to your level by placing it on a table.

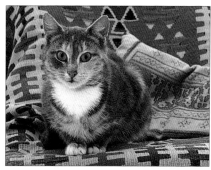

△ RECORDING YOUR CAT
Cats can be too sedate to make good subjects. Wait until your cat is in a playful mood.

FEATHERED FRIENDS
Even with small subjects such as birds, shooting at eye level is important for maintaining a one-to-one relationship between your subject and the viewer.

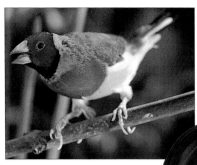

100 BIRDLIFE

Birds can make interesting and colorful subjects, and you may not have to travel any farther than your own backyard to shoot them. Ideally, set up a feeder and note the times that the birds come to eat. Be ready the next time and set up where you can see them, but they can't see you. The most convenient option is to shoot from indoors – poking the lens through an opening in the curtains.

BIRDWATCHING
A teleconverter and a tripod are essential for obtaining effective close-up shots of birdlife.

101 HOW TO FILM WILDLIFE

Shots of more exotic animals can be obtained relatively easily from the safety of your car at safari parks. Other wildlife sanctuaries offer good opportunities for interesting shots. Determine feeding times in advance, to catch animals at their most active.

- Successful shots in the wild require great patience. Read about your subject's habits before setting out.
- Shoot early or late for the most advantageous light conditions.
- Inconspicuous clothing will help you to get closer to your subject.

SMALL WONDER △
Beautiful subjects can be found in your own garden.

◁ **MONKEY BUSINESS**
Respect wildlife. Do not use strong video lights that will distress wild animals.

INDEX

Acknowledgments

Dorling Kindersley would like to thank Hilary Bird for compiling the index, Ann Kay for proofreading, and Janos Marffy for illustrations. Thanks also to Mark Lewington and Katrine Follows of Panasonic U.K. Ltd for the loan of equipment. Special thanks to Susila Baybars, Richard Hammond, Daniel O'Sullivan, and Clive Hayball for modeling.

Photography
KEY: t *top*; b *bottom*; c *center*; l *left*; r *right*
All photographs by John Bulmer except for:
Jane Burton 68t; Peter Chadwick 66tl; Geoff Dann 39b;
Mike Dunning 38b, Philip Gatward 37bl, br, 39t, 40b, 41bl, br, 43b,
48, 51tl, 54b, 63tr, 66tr; John Heseltine 65tl, tr; Mary-Clare Jerram
63tl; Neil Lunas 38t, 64; Damien Moore 17t, 21tl, bl, 38b, 58tl;
Susanna Price 3, 4, 5, 8, 9, 10, 14b, 18b, 23, 24, 25, 26, 27, 28, 29tl,
31, 32l, 33, 41t, 44b, 45tl, tr, cl, cr, 46bl, 66bl, 71, 72;
Matthew Ward 67b; Jerry Young 69tl, bl, br.

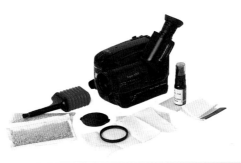